Missed Connections

LOVE, LOST & FOUND

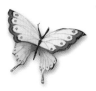

By SOPHIE BLACKALL

WORKMAN PUBLISHING • NEW YORK

For Ed

Library of Congress Cataloging-in-Publication Data is available.

ISBN 978-0-7611-6358-9

Art Direction by Janet Vicario
Design by Ariana Abud

Workman books are available at special discounts when purchased in
bulk for premiums and sales promotions as well as for fund-raising or
educational use. Special editions or book excerpts can also be created to
specification. For details, contact the Special Sales Director at the address
below or send an e-mail to specialmarkets@workman.com.

WORKMAN PUBLISHING COMPANY, INC.
225 Varick Street
New York, NY 10014-4381
www.workman.com

Printed in China

First printing August 2011

10 9 8 7 6 5 4 3 2 1

contents

introduction. When I was seventeen I found myself at a dusty crossroads on the outskirts of a shadeless Turkish town in the heat of an August day. I had been drifting across Europe with a raggle-taggle bunch of backpackers, who had one by one dropped off to stay behind in sexier countries. By Turkey there were just two of us, me and an English girl. We were sick of each other's limited, rumpled wardrobes and annoying personal habits, but here we were, stuck together at a crossroads in Turkey.

Out of the haze rumbled a pickup truck. Five or six shirtless young men slouched languidly in the back. One of them had incredible, surprising blue eyes. He stared right at me, and I stared right back at him. He was the most beautiful boy I had ever seen. Time screeched to a halt and I pictured myself in slow motion taking a running leap into the bed of the truck. I would land gracefully next to him, catching his outstretched hand. We would drive up to his village in the mountains where we'd recline in picturesque ruins, feeding each other figs plucked from a low-hanging bough. The moment lasted just long enough for me to conjure a crisp white dress (clean clothes were a big part of every fantasy at the time) before the truck moved on. The possible love of my life gave a small wave and disappeared forever, legs dangling in a cloud of dust.

I didn't speak Turkish; he probably didn't speak English. I didn't know where he was going or his name. I didn't have a cell phone. The Internet didn't exist. The only way to make contact would have been to leave messages in youth hostels, more or less the equivalent of scattering a trail of bread crumbs. I did neither, but I thought of him. And wondered if our children would have had blue eyes, and if he ever thought of me. At seventeen, though, I wasn't one to dwell. My Turkish romance was short-lived and I turned the page. After all, there was a whole world waiting for me.

Most of us have experienced a Missed Connection. Untold people a day kick themselves for not being bolder, braver, more spontaneous. Right this second two guys in suits are eyeing each other as they step around the garbage on Market Street in San Francisco. A delivery man in Hell's Kitchen, New York, is wishing he had paused to hold the door for a dark-skinned woman with a pink scarf. In Cedar Rapids, Iowa, a man and a woman pull

up at a crossroads. They are inexplicably drawn to each other. They stare through their windshields, and imagine rolling down the window to say hello. They imagine going to a diner up the road for coffee, imagine their first kiss, whether the other prefers the left or right side of the bed. The lights change and they drive on in different directions. *(Of course I'm just guessing what these people were imagining; I'm not acquainted with either of them. For all we know, the woman was staring into space dreaming of what to have for lunch. Just as my waving Turkish boy might have been swatting a gnat.)*

Before the day is over, one of those two instant lovers and thousands more will write Missed Connections and post them online.

Saw you just now at the cnr of Old Marion Rd and 42nd in a light blue pickup. I was driving the maroon Oldsmobile. Our eyes met. I think you might be the love of my life. You probably won't read this, but I'd like to buy you coffee.

These notices have about as much chance of reaching their intended recpient as a message in a bottle or a note written on a paper plane launched from the Empire State Building. But slightly more chance than leaving a trail of bread crumbs.

I received twenty-seven e-mails this year from happy couples united after having posted a Missed Connection. Some even sent photos. Six of them asked me to illustrate their wedding invitations. Several yearning types wrote, begging me to help them find their lost loves. How on earth (you may ask) did I find myself in the position of love guru?

This is how.

Being an illustrator (did I mention I'm an illustrator?) is a mostly wonderful thing. You get to draw wild boars and rocket ships and petticoats and harpoons. You get to choose your hours (which is often all hours, but still, you're the one choosing them . . . at least that's what you tell yourself), you can wear whatever you like (today I am wearing a peacock-feather cloak), listen to songs that include a whistling coda (might not be to everyone's taste), and talk back to Ira Glass as though he's in the room. You can spend most of the day on the Internet and call it *research*.

All this isolation can be good for productivity. It can also lead to an atrophied palette, compulsive blogging, and thinking of Ira as your friend.

Once a week I make sure I leave my windowless cell in Brooklyn and go into Manhattan, either to see an editor or buy feathers, or to look at the stupendous armor at the Met or at tattoo catalogs on the Lower East Side. One day I squeezed into a subway car with a bushel of peacock feathers and a pound of sea scallops, and a handsome chap squeezed in next to me. We apologized in rounds, and when he stepped off he appeared in the window and mouthed two words. I turned to the girl next to me.

"What did he say?" I asked.

"Missed Connections," she said.

I had no idea what she was talking about, but I didn't want to seem uncool, so I made a mental note.

I got home, dropped my scallops and feathers, went to the computer, and looked up Missed Connections. (I'm easily distracted; I knew I wouldn't retain it for long.)

Here is the first one I read:

You had a guitar, I had a blue hat
- m4w - 28
We exchanged glances and smiles on the subway platform.
I pretended to read my New Yorker but I couldn't concentrate.
You got on the Q and I stayed on to wait for the B. You were lovely.

In the space of eight seconds I had experienced love, loss, and regret. I held my breath and clicked on the next post.

And the next.

And the next.

It was dark long before I tore myself away. The scallops were room temperature and my head was bursting. (*The handsome chap on the subway was completely forgotten in my excitement. I have no idea if he ever left a message.*)

In a given day there are so many things to draw and stories to gather; it's hard to choose between feathers and armor, scallops and sailors' tattoos. I'm a gleaner, always on the lookout for material. I pick up anything handwritten and crumpled. I eavesdrop shamelessly on buses. I collect old photographs and sift through faded telegrams at flea markets. Any of these things can supply the inspiration for one good picture, maybe two . . . but then what? (*The*

telegrams were a bit disappointing—they were all about the shipment of dry goods, except the one which read COME QUICK BEAN SICK STOP.)

Back to the scallops for a minute. They had been sitting out for hours and hours. And I couldn't be 100 percent sure the cat hadn't licked a few of them. I felt a seeping, creeping wave of guilt. It was akin to frittering away hours on eBay when I have a deadline, or looking at donkey breeders' websites when I have no intention of buying a donkey. But then I remembered the golden rule:

If you like doing something, find a way to call it work.

I liked reading Missed Connections. I would make paintings of them. I would post them on a blog (I had yet to figure out how exactly one managed this), which would make me actually follow through, instead of having the idea and filing it away in my brain along with all the other brilliant ideas I can no longer remember. The spoiled scallops were a small sacrifice.

Unlike crumpled notes, Missed Connections were bountiful. They appeared online faster than I could read them, and I didn't even have to leave my desk to find them.

You just dropped your black scarf on the 10th floor of the New School building on 16th street. You're very cute. I yelled and you didn't turn around. It's still sitting there as I type this on the floor of the hallway. Should I pick it up?

I'd found treasure; I was a pirate in a picture book, cackling and throwing gold coins in the air.

Then I realized the posts had a limited lifespan. They dropped off Craigslist after a week. Gone forever. I went into a slight panic. I started gleaning in earnest and archiving. I figured out how to set up a blog. (My grandmother could set up a blog.) I painted the guitar and blue hat. I kept gleaning. I kept painting and posting and gleaning. I didn't tell anyone. Partly because I had a list of overdue illustrations and I had no business doing extracurricular drawing. Partly because it felt a bit like joining a gym. (You don't want to announce a new fitness routine unless you're going to stick to it. Otherwise you have to avoid everyone you told until they forget.) Also, I didn't really think anyone would read it. (*This is a hypothetical comparison. I have never joined a gym.*)

Then a strange thing happened. I started getting comments. One came in the very first day. It read:

CIAO!!!
bello il tuo blog complimenti . . .
Auguro di una felice primavera
e un salute . . . Dall'ITALIA
 LINA

I'm not quite sure what it said, but it *sounded* nice. Comments began to come in thick and fast. People asked to "follow" my blog or wrote about the pictures and posted them on their own blogs. E-mails came from Greece and Saudi Arabia, from the Netherlands and New Zealand and Hong Kong. Magazines asked for interviews. *The New York Times* called. And regular people wrote, begging me to help them find their lost loves. They told me my pictures had made their day, had pulled them out of a funk, had put a spark back in their marriage. Had given them hope. Hope in kindness and intimacy between strangers, hope in finding their own true loves. Hope of connecting. Because for all the hopelessness in writing and posting a Missed Connection, for all the "You probably won't read this" and "This is a shot in the dark," there's a 15-watt bulb of hope dimly glowing in each message.

With this deluge of response came the realization that I was not alone in finding Missed Connections as seductive as a Hugh Grant movie, as addictive as Facebook. (Just five more minutes to look at photos of the girl-I-was-never-friends-with-in-high-school's baby shower . . .) I knew why I was glued to them, but I wondered if those reasons were universal: the voyeurism, the vicarious romance, the unintentional comedy, the angst, the imagery. The more Missed Connections I collected, the more I wondered about the other readers and even more about the authors themselves. In the beginning I actually wrote to the anonymous authors whose posts I illustrated. It was supposedly a courtesy e-mail to explain my project and give them an opportunity to object, but really I was curious to know more—whether the posts had received any responses, if this was the first time each writer had been inspired to reach out or if they were regular posters. I must have sent twenty e-mails, but I had only one reply, from a man named John. "I don't really expect to hear back," he said. "I guess I write them mostly for myself."

In an effort to understand the Missed Connections better, I found myself sorting them into categories. There is the standard formula, which states the location, the time, a brief description of the person sighted, and a regret at not making contact:

> **You were on the F train yesterday around 10:30 in the morning. You were reading a purple book — I think it was Lady Chatterly's Lover? Beautiful eyes. Reddish hair. I should have said hi.**

There are the ones written to a known person, which deviate from the formula, but this person is usually inaccessible, either for ethical reasons:

> **You are my therapist . . .**

Or because the relationship is over:

> **i miss it sometimes . . . you and me . . .**

Or because the person is famous, or dead, or both:

> **To Henri Matisse's Daughter, Margeurite: I still think you are the most beautiful woman in the world, past or present.**

Some are thrown out to the universe with a specific intent:

> **I am trying to track down a long lost love of a dear friend. My friend was in a very bad car accident in his 20's that made him unable to use one hand. He had a son with this 'drop dead gorgeous' jewish woman in NY about 40 years ago. They lived together before it was status quo. They loved each other, but he says they were destructive, so he left. But he never forgot her, or his son. I promised I would try to find the woman or her son. He knows neither one may want to see him. This man is the closest thing I have to a father, I am proud to be his friend, and I think he is worth knowing, even now.**

Or a vague intent:

> **i read these ads everyday. i really don't want anything from any of you. well, nothing material, and as i write this, nothing seriously sexual. i know if you're reading these ads, you're looking for something just like i am. i'm most likely not it, but i really hope you find it. i really hope you keep your hope.**

A few try to twist the system:

> **If you want to have a missed connection with a really hot girl
> then walk south on 1st avenue on the east side of the street
> between 8th & 9th st. at 3:30pm saturday. I'll be walking
> opposite you.**

Some are written moments after the encounter took place:

> **I made eye contact with you just now on the uptown C. I got off
> at 23rd St and am standing at the top of the stairs shivering
> and wishing I'd had the nerve to stay on the train and talk to you.**

Or decades later:

> **I'm looking for a lady called Elsie who used to live in
> Peekskill NY in 1954. she may have been married some years
> now, this may not be her name now, she may be your mother
> or grandmother, or a good friend, she wrote to me when I was
> in Korea, for years I have never forgot her, for her kind letter
> that made me think of home . . .**

There are also angry ones, perverse ones, lonely ones, drunken ones,
and some that are clearly hoaxes. I read a post from a thief, for example, a
love note expressing the admiration he felt for his victim's shapely contours
as he snatched her purse. There are several like this, ranging from unlikely
scenarios to preposterous ones, and I can't help thinking they have a hint of
the creative-writing exercise about them. I am intrigued by these, but I don't
often want to draw them. I prefer to make pictures of the simple ones with
peculiar details; lyrical ones with striking imagery; misspelled ones that are
often unintentionally hilarious; and tender, surprisingly moving ones. For all
I know these, too, might be completely fabricated, but the ones I have chosen
to paint somehow ring true to me.

⎯⎯⎯

For regular readers of Missed Connections, and there are many of
us, I think there exists, deep down, a small desire to maybe, possibly
stumble upon ourselves described:

> **Around 4:45pm today I got on the Queens-bound V train at
> Lex. I noticed you immediately; you had on a blue shirt, tall
> boots, black leather jacket. We were both listening to music.**

It looked like you kept glancing at me, but there is a distinct possibility that we kept making shy eye contact because I couldn't stop looking at you. You got off. I didn't. Feels like regret to me. Damn, I should have spoken up. You were gorgeous. Too gorgeous to check these. Damn.

I bet most of us who read this message at the time did a subconscious checklist. Hey, I'm often on that train! And I have a blue shirt! And my boots *could* be considered tall. Damn, no black leather jacket.

Damn.

It's not that we're really looking for someone. (I'm in a happy relationship, blah, blah. Also, I recently turned forty. Most messages are directed at people UNDER thirty-five. Brutal.) But who doesn't want to be found attractive by strangers?

It's also nice to know people are paying attention to one another, noticing tiny details ("the cute gap between your teeth," "you had a bruise on your cheek," "your shoelace was untied," "you were using a paper plane as a bookmark"). The enormous amount of tenderness in these messages makes me all swoony about my fellow human beings.

———

The way we communicate these days (technology! the Internet!) must have something to do with why Missed Connections are so popular. There's an argument that technology impedes social interaction (why don't people just talk to each other anymore?), but the "missed connection" itself is not new. For centuries the lovelorn have carved messages in tree trunks and rolled letters into bottles and cast them out to sea. On the 19th of January, 1862, the following appeared in *The New York Times*:

If the young lady wearing the pink dress, spotted fur cape and muff, had light hair, light complexion and blue eyes, who was in company with a lady dressed in black, that I passed about 5 o'clock on Friday evening in South Seventh Street, between First and Second, Williamsburg, L.I., will address a line to Waldo, Williamsburg Post Office, she will make the acquaintance of a fine young man.

In 1862 it would have been indiscreet, even for a fine young man like Waldo, to approach a young lady without an introduction—we're a bit more relaxed about things now. And yet, invisible membranes keep us apart. On a red-eye from L.A. at 3 A.M., when you're not sure where your limbs end and the next person's begin, it can be difficult to break through that membrane to say hello to the owner of the attractive thigh on your right.

You don't want to seem creepy. Or desperate. Or you might be reviewing the ensemble you picked up off the bedroom floor in haste and regretting the I AINT SCARED OF NOPOPO T-shirt. Maybe you're not sure if the person next to your potential beloved is more than a friend, or even if you bat for the same team. Or maybe there's just not enough time (or too much time):

> **Today we made excellent eye contact on the downtown E. My brilliantly conceived and flawless plan was to ask you for a pen, then use it to write down my phone number. Just needed to work up the nerve to do it. My stop approached—it was now or never. I got up and walked over. No, you didn't have a pen. Ok, plan B. There was no plan B. Went straight to plan C, which I'll call the "Chaplin"—I stood there, totally silent for an agonizing eternity until my stop finally came. Does anyone realize how long it is from 14th street to w4? Well, it's long.**

I ache for Charlie Chaplin and his silent yearning, but he is not alone. Well, he is alone, but his situation is not unique.

A subway car of New Yorkers at rush hour is like a droplet of pond water under a microscope . . . teeming with activity. Passengers may seem self-absorbed and reluctant to make eye contact, but if you channel David Attenborough and sit quietly and watch, you'll see fleeting glances and half-smiles and cotton-wool mouths and racing thoughts. Well, you won't be able to see those last two, but they're there. And it's not just the subway. People miss each other on street corners and in cafés, walking their dogs and getting their hair cut, and at the gym and the grocery store, on rooftops and in elevators and even in the emergency room. And obviously not just in New York. At a crossroads in Turkey or Cedar Rapids, Iowa. On highways and in national parks and airports, and anywhere human beings collide. And each individual collision is a fragment of a story containing great big familiar themes of love, loss, and regret and, ultimately, and most importantly, hope. It's a hopeless sort of hope,

but it's very compelling. We want to know if the guy gets the girl, don't we? (*Incidentally, messages from men outnumber messages from women about 70 to 30.*)

I have a confession to make.

I don't really want to know. I like a happy ending as well as the next person, but I love the mystery and the uncertainty and the electric current of possibility.

There's a reason the best love stories end at the first kiss. Jane Austen had this down; it's all about the chase. We're not really interested in Elizabeth and Darcy after the wedding bells fade, or in Cinderella and her prince after the slipper is returned.

Love at first sight is almost entirely visual. In most cases we don't even hear the other's voice. I think there's a lot to be said for this. We can fill in the blanks and create our own particular rosy ideal. As you glimpse your angel across a crowded room you have no need to accommodate her overbearing mother; noticing your dreamboat on the morning ferry you have no reason to suspect his tendency to forget your birthday. The less you know, the more creative you can be. In my brief foray into online dating I found the amount of information boggling. Also, and I'm not proud of this, I found myself dismissing potential dates based on how they described the contents of their fridge or the books they said were piled on their bedside table or, even more shallowly, on a misplaced apostrophe.

I'm not an idiot: In the long run, knowing someone intimately and caring for them deeply leaves love at first sight for dead. Clichéd as it is, it's a wonderful thing to have someone you love bring you a cup of tea when you have a cold, or curl up with you to watch a film on a rainy night, or turn the oven on while you knead the dough. Someone who will be there when you can no longer put on your underpants standing up. Some of us find that person early on; for the rest of us there's the hope of a second chance. And that hope can linger for a long, long time. (If the Missed Connection on page 90 doesn't kill you, I no longer want to be your friend.)

We have only one life, and we rush through it. We make choices and follow paths and we don't linger too long at crossroads. Moments of intimacy with strangers are minor detours we rarely explore, but those moments make us feel alive, and human, and part of something greater than ourselves.

They connect us to each other.

Right this minute a man in a barber's chair is feeling the swish of a soft brush on the back of his neck. He believes the barber has the most beautiful hands he's ever seen. A woman realtor is showing a gentleman an apartment. She imagines moving in with him, thinking he is the type to own lots of books and hoping he won't object to her cat. Two girls with headphones pass each other in a hallway. One drops her books and curses while the other wishes she had stopped and turned back to help, and maybe suggested coffee, but each step is taking her in the wrong direction. A young vegetarian man is admiring a girl's white fur hat in a park and wondering if it's real fur and if he cares, because what's underneath it is so damn cute. I hope one of them says something, but I also kind of hope they wait until later and post Missed Connections so I can read their unfolding stories, and see the flickering pictures form in my head and take shape on my page. Maybe one of them will post a message and maybe, just maybe, the other person will happen to go online the next day and read it, recognize the encounter, and respond to the message and arrange to meet and fall in love. Probably not. Maybe the one who writes the message doesn't really expect an audience. Maybe, like John, he's writing mostly for himself—throwing a message to the universe to intercept fate or something.

But I am there, reading and taking notice. I am the audience and, now, so are you.

You Had a Guitar. I Had a Blue Hat.

– M4W – 28

We exchanged glances and smiles on the subway platform. I pretended to read my New Yorker but I couldn't concentrate. You got on the Q and I stayed on to wait for the B. You were lovely.

Monday, March 9

- m4w -28

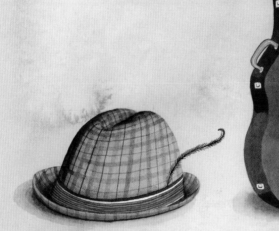

You Had a guitar. / Had a blue Hat.

We exchanged glances and smiles on the subway platform. I pretended to read my New Yorker but I couldn't concentrate. You got on the Q and I stayed on to wait for the B. You were lovely.

Doing Laundry in Our Building

– M4W – 26

Unfortunately I hardly looked up, but I'm pretty sure you were beautiful. Hope to see you again.

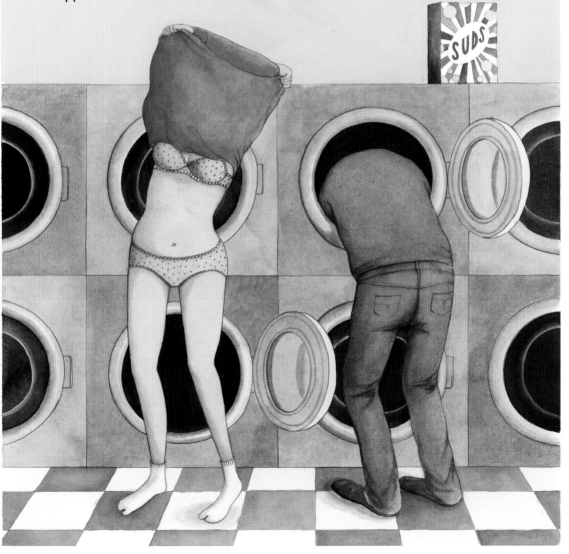

We Shared a Bear Suit

– M4W

We shared a bear suit at an apartment party on Saturday night. I asked for your number and you gave it to me, but somehow I don't have an area code written down. I had a great time talking with you, and I don't trust Chance enough to wait until I see you in the elevators . . .

WE SHARED A *BEAR SUIT*
AT AN APARTMENT PARTY Saturday Night
— m4w

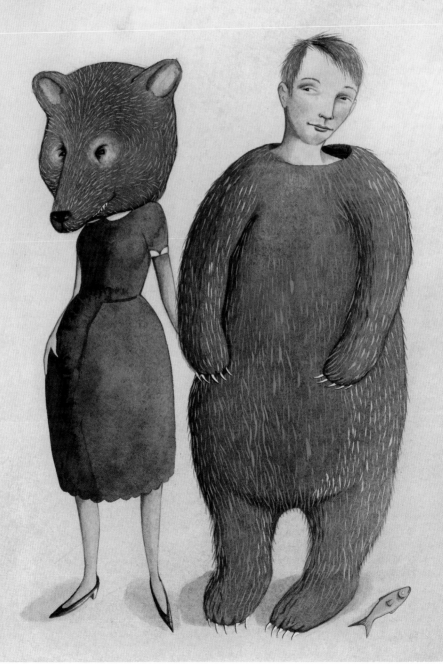

I Bought You That Milkshake

- W4M - 22
(WILLIAMSBURG)

you just didn't realize it.

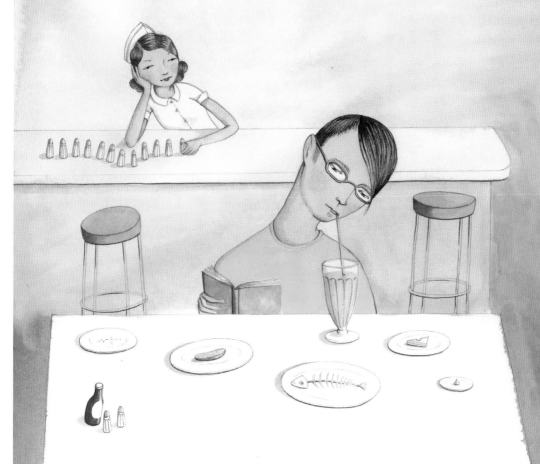

Long Curly Brown Hair on the Q

– M4W – 36

You had pink fingernails and got on the Q train at Atlantic
(if not Dekalb). I felt an irrational desire to invite you out to
dinner. I found you stunningly beautiful, but you'll probably
never know. I think you changed trains at Times Square
and I watched as you stepped between closing doors and
disappeared. If for some reason you check this, it'd be
nice to hear from you. Either way, I hope you're well.

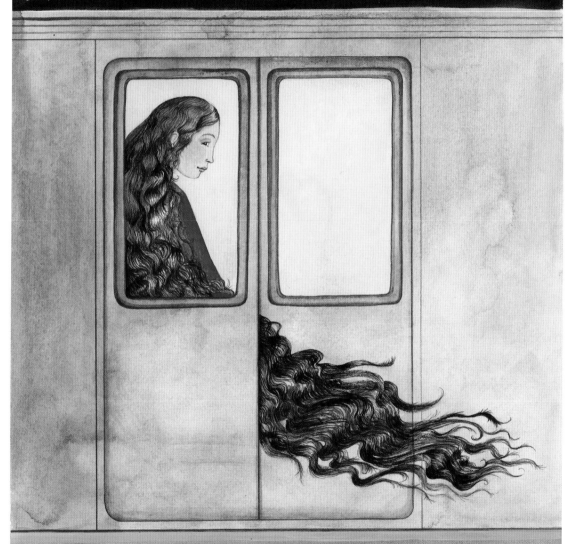

LONG CURLY BROWN HAIR ON THE Q

YOU HAD PINK FINGERNAILS AND GOT ON THE Q TRAIN AT ATLANTIC (IF NOT DEKALB). I FELT *AN IRRATIONAL DESIRE* TO INVITE YOU OUT TO DINNER. I FOUND YOU STUNNINGLY BEAUTIFUL BUT

YOU'LL PROBABLY NEVER KNOW. I THINK YOU CHANGED TRAINS AT TIMES SQUARE AND I WATCHED AS YOU STEPPED BETWEEN CLOSING DOORS AND DISAPPEARED.

If Not For Your Noisy Tambourine

– M4W – 19
(UPTOWN 3 TRAIN)

If not for your noisy tambourine, I would not have seen you.
Your green skirt looked terrible but that leather jacket makes
you look just right. I was the attractive guy sitting to your left
just before you got off.

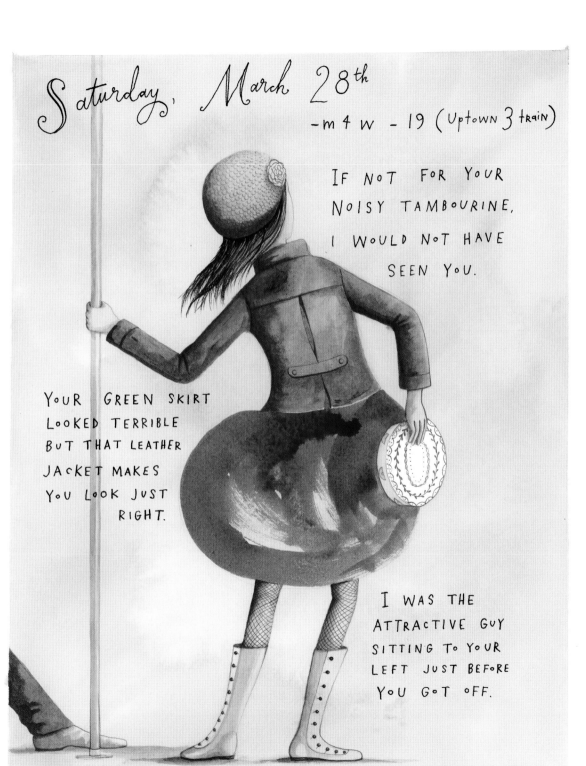

Valentine's Day

– M4W

If, like me, you don't have someone "special" to exchange heart-shaped confectionery with today, how about this: As you go about your business find six strangers to connect with. It could be as simple as "hello" or "I liked your hat." It will make you feel good, probably make six strangers' days less lonely, and who knows, maybe one of those strangers will be me, and maybe I'll like your hat too, and maybe we'll go for coffee and fall in love and maybe next year we'll exchange hat-shaped confectionery. I mean, why not?

Bleeding Nose on the F

Your nose started bleeding when we went under the river this afternoon. I was the girl who handed you a handkerchief. It didn't seem an appropriate moment to ask if you were single, but I thought you were bloody lovely.

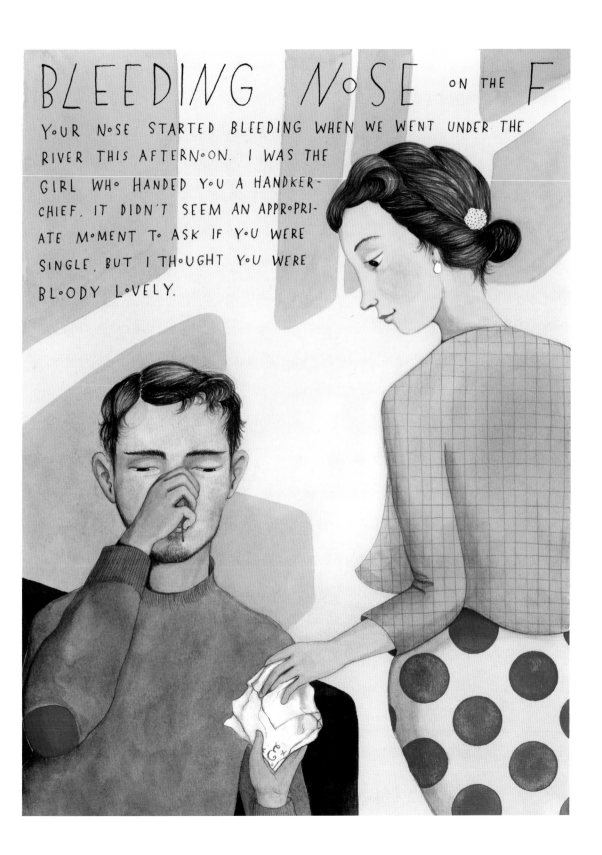

BLEEDING NOSE ON THE F

YOUR NOSE STARTED BLEEDING WHEN WE WENT UNDER THE RIVER THIS AFTERNOON. I WAS THE GIRL WHO HANDED YOU A HANDKER-CHIEF. IT DIDN'T SEEM AN APPROPRI-ATE MOMENT TO ASK IF YOU WERE SINGLE, BUT I THOUGHT YOU WERE BLOODY LOVELY.

Passed You on Street, U Said Hi

– M4M
(UPPER WEST SIDE)

Passed by you around 11pm tonight on street, UWS in 70s.
You said hi, and I said hi as well. We both went into our
respective buildings.

Do You Believe in Love @ First Sight?

- M4W
(L TRAIN)

You were reading Catch-22 on the subway this morning.
I have never seen such a beautiful profile. I wanted to say hi,
but then you'd turn towards me and I wouldn't be able to
look at your profile anymore. You were so into your book,
I don't think you noticed me falling in love with you. But I
thought I'd ask, just in case.

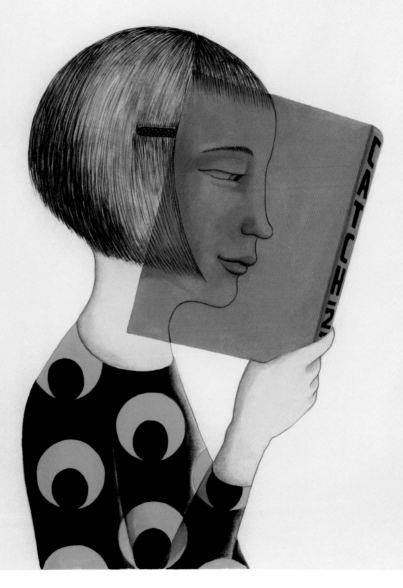

Floral Print Jacket on the L

- M4W - 26
(UNION SQ)

Can I buy you a drink?
—Buffalo plaid jacket

FLORAL PRINT JACKET

ON THE L. -m 4 w - 26 UNION Sq

CAN I BUY YOU A DRINK?
- BUFFALO PLAID JACKET

Hot Toll Collector

- M4W - 35
(OUTERBRIDGE)

I complimented you on your new look today. Hope you see this. I was too shy. The $8 was well worth it, & always is when you're there.

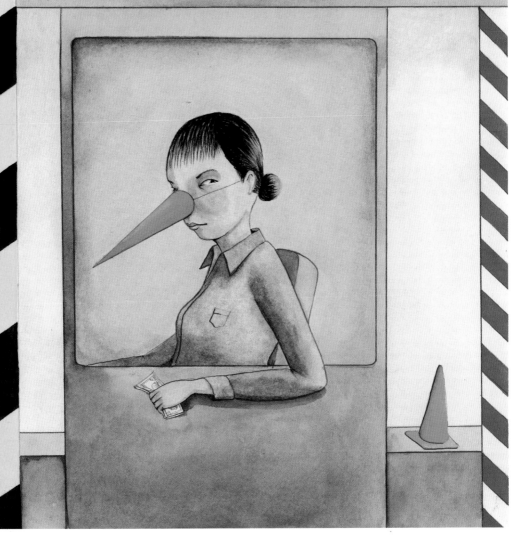

Phoenix w/ Crutches

- M4M
(EAST VILLAGE)

I would love to carry you around piggy back until you can
walk again . . .

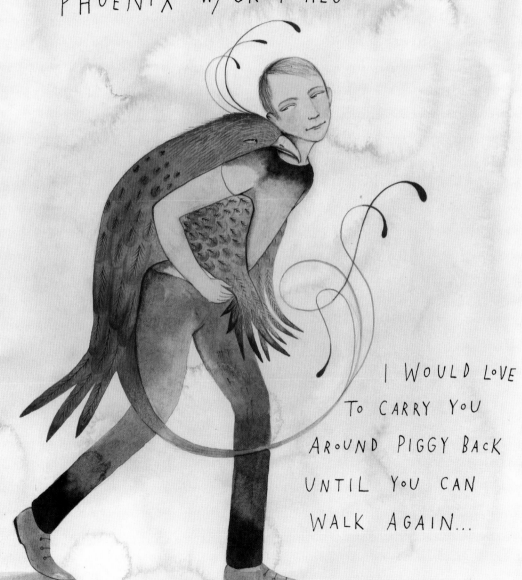

We Talked About Rent & Africa on the L

– M4W – 25
(CHELSEA)

I was with two friends who you considered negative. I would like to meet you again, you were funny. Also I have big hair . . . blue jacket.

WE TALKED ABOUT RENT & AFRICA ON THE L
— m4w - 25 - chelsea

I WAS WITH TWO FRIENDS WHO YOU CONSIDERED *NEGATIVE*
I WOULD LIKE TO MEET YOU AGAIN, YOU WERE FUNNY.
ALSO I HAVE BIG HAIR ... BLUE JACKET.

Are You Scared of Birds or Something?

– M4W – 20
(WILLIAMSBURG)

Well, whatever the case, it was cute. Do you live on N 7th too?
We could hang out.

Freckles and Bruises

\- M4W - 23
(L TRAIN)

How did you get those bruises? I wouldn't let anything happen to you. You were reading some book, and taking notes. I read a book once.

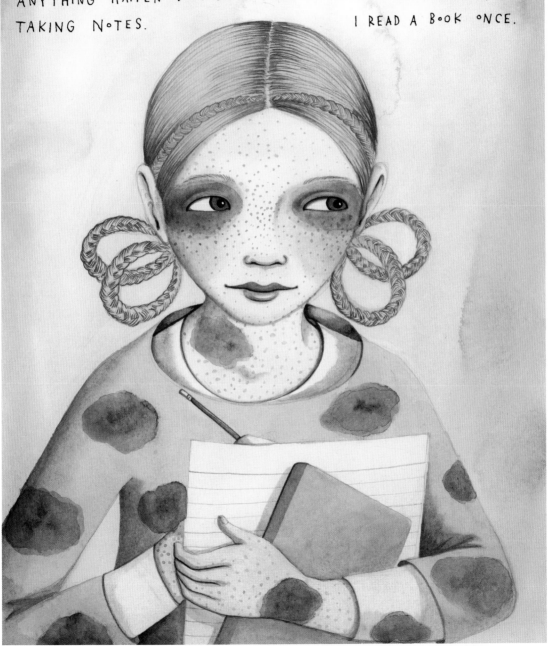

Chinese Food in Queens

- W4W

I met you in a Chinese restaurant nr Juniper park, you ordered General Tso's Chicken and we talked about horseback riding briefly. I thought you were cute.

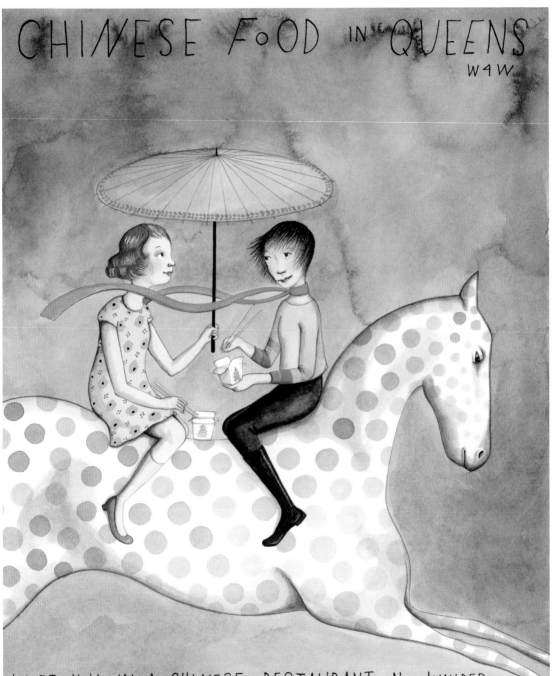

Butterflies @ the Museum of Natural History

– W4M

Not just those on show, you know that, right?

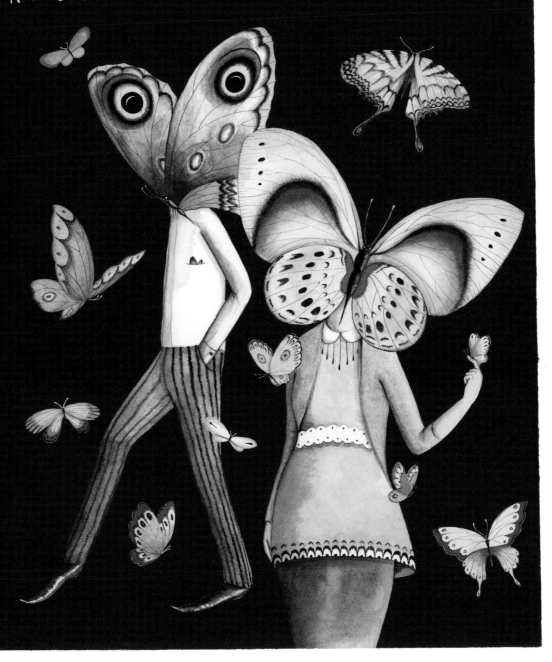

BUTTERFLIES @ THE MUSEUM OF NATURAL HISTORY w4m
NOT JUST THOSE ON SHOW, YOU KNOW THAT, RIGHT?

Red Book, Blue Book

- M4W - 31
(F TRAIN, 7TH AVENUE)

Look: historically, I'm not a morning person. And to top it off, I was grimacing through some lower back pain that flowered over the weekend. So when you noticed me (white guy, brown hair, blue/white striped shirt, earphones, red book) and I noticed you (white girl, brown hair, nosering, headphones, blue book) for however brief a moment this morning, it was bolstering and made me forget the knife in my back. Haven't noticed you before, but if there's a next time, maybe I can slap myself out of the morning slumber and say hey. No promises, though.

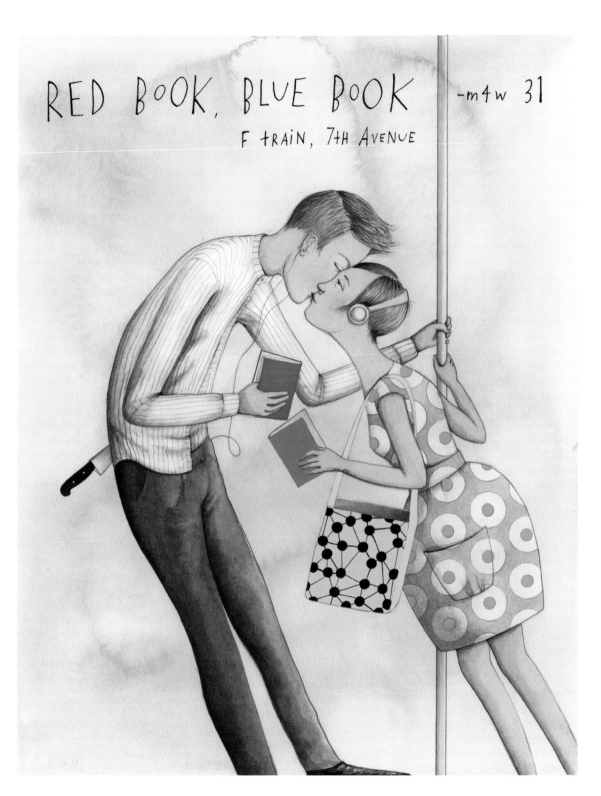

Hipster Chick Who Passed Gas on Ⓐ Train

- M4W
(HARLEM)

Remember? Uptown A train.
I was the black dude reading Bukowski's Post Office. You
were reading the Arts and Leisure section. You passed wind
rather loudly and started chuckling. I'd like to see you again.
The flatulence wasn't a turn off.

Greenpoint Laundromat

- M4W - 27

I am a nice, quiet guy and I am about to have a missed connection with someone at my local laundromat when I go in half an hour to do my laundry. I'll probably be sitting in a corner reading, because I don't like to leave my laundry alone. Maybe you're there doing your laundry too?

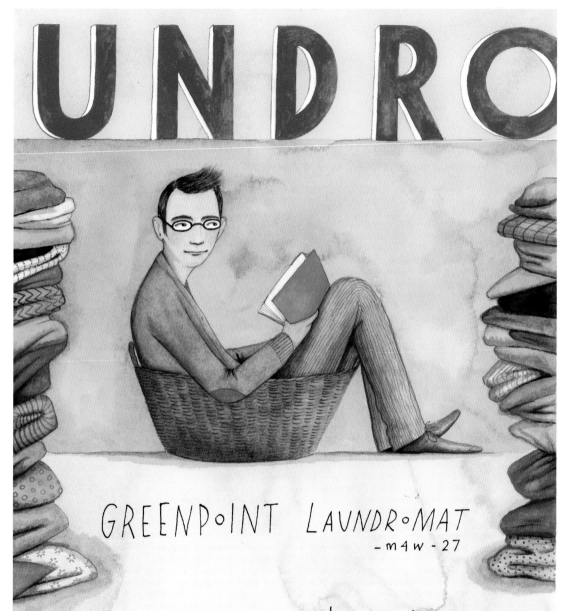

UNDRO

GREENPOINT LAUNDROMAT
– m4w – 27

I AM A NICE, QUIET GUY and I AM ABOUT TO HAVE A MISSED CONNECTION WITH SOMEONE AT MY LOCAL LAUNDROMAT WHEN I GO IN HALF AN HOUR TO DO MY LAUNDRY. I'LL PROBABLY BE SITTING IN A CORNER READING, BECAUSE I DON'T LIKE TO LEAVE MY LAUNDRY ALONE. MAYBE YOU'RE THERE DOING YOUR LAUNDRY TOO?

I Wish I Could See Inside Your Head

– M4W

You were wearing a green dress with white buttons. We made
eye contact at least three times on the 6 train this morning.
All of a sudden you gave a little smile, and looked down at your
lap, as though at some secret joke. You never looked up again
and I had to get off at Bleecker. I wish I could have seen inside
your beautiful head.

I WISH I COULD SEE INSIDE YOUR HEAD -m4w

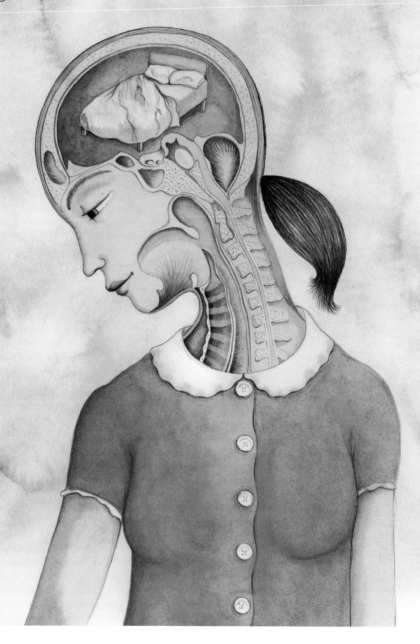

The Coming and Going of Bicycles (that's life)

sorry your bike got stolen. its beautiful. when some guy offered it to me for 40 bucks, i didnt even think twice. i was drunk, missing my bike and figured if not me, someone else would buy it anyways. also, my bike got stolen last week. who knows, maybe you bought it for 40 bucks from some guy on the street. so if you see me riding it, feel free to say hey. maybe we could trade back. if not, you can buy it from me for 40 bucks. id buy my old bike back for 40 bucks. it was way more comfortable than this one.

THE COMING AND GOING of BICYCLES (that's life)

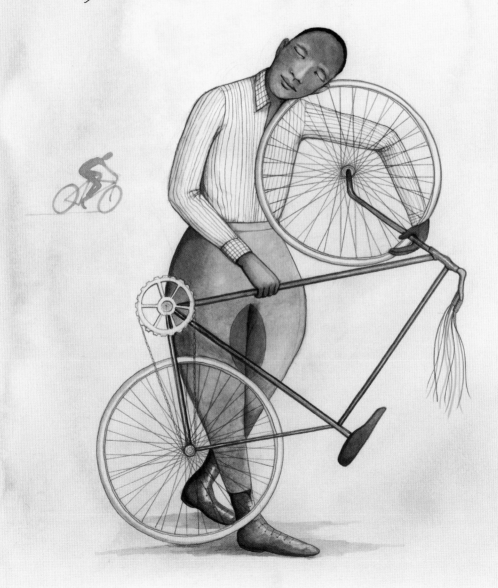

Throat Tattoo

(L TRAIN)

Hey, guy that got on at 1st Ave dressed all in black with the
throat tattoo. Thanx for existing.

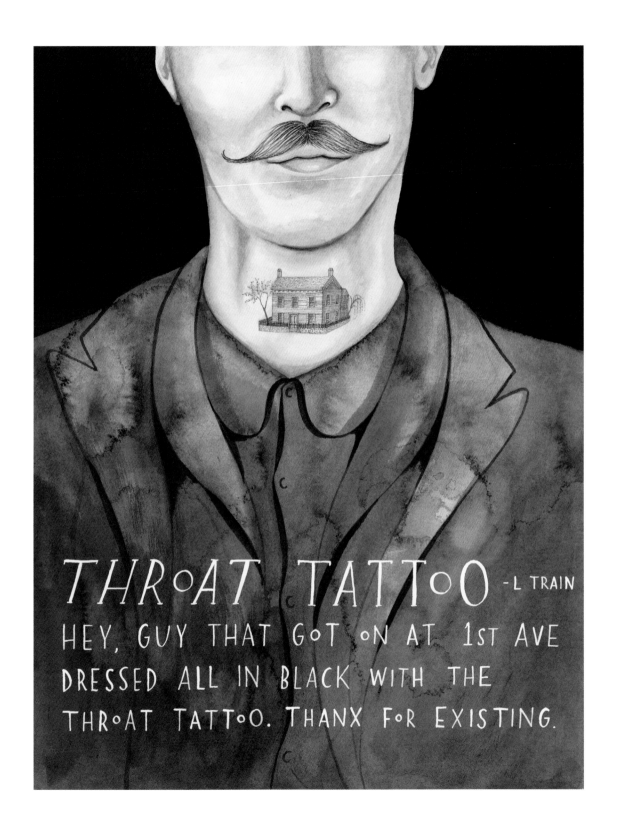

THROAT TATTOO -L TRAIN
HEY, GUY THAT GOT ON AT 1ST AVE
DRESSED ALL IN BLACK WITH THE
THROAT TATTOO. THANX FOR EXISTING.

In the Library, Browsing

– W4M

We were in the Brooklyn Public Library on Saturday, browsing
graphic novels—you had on a big furry hat and nice smile.
You tapped me on the shoulder and told me I'm pretty.
That was nice. Which book did you end up borrowing?

IN THE LIBRARY, BROWSING —w4m

WE WERE IN THE BROOKLYN PUBLIC LIBRARY ON SATURDAY, BROWSING GRAPHIC NOVELS — YOU HAD ON A BIG FURRY HAT AND NICE SMILE. YOU TAPPED ME ON THE SHOULDER AND TOLD ME I'M PRETTY. THAT WAS NICE. WHICH BOOK DID YOU END UP BORROWING?

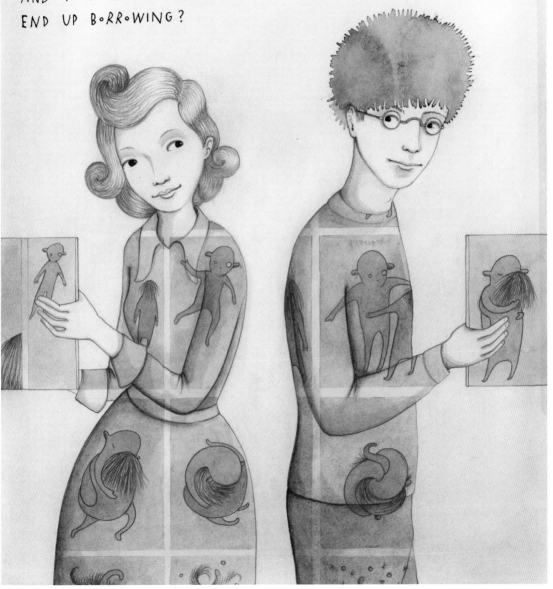

How Come No-one Ever "Misses" Me?

\- M4M

How come no-one ever "misses" me ?

Help with Luggage

- W4M - 23

I just wanted to say thank you for offering to help carry my little orangey-pink suitcase. It really meant a lot because I was having a really terrible day.

—Half Asian girl in the green shirt

HELP WITH LUGGAGE -w4m

I just wanted to say thank you for offering to help carry my little orangey-pink suitcase. It really meant a lot because I was having a really terrible day. — HALF ASIAN GIRL
in the green shirt

Bonsai Girl

- M4W

You were at the Botanical Gardens on Saturday. I saw you through the bonsais. I wanted to call out Hey! but it was quiet as a library in there.

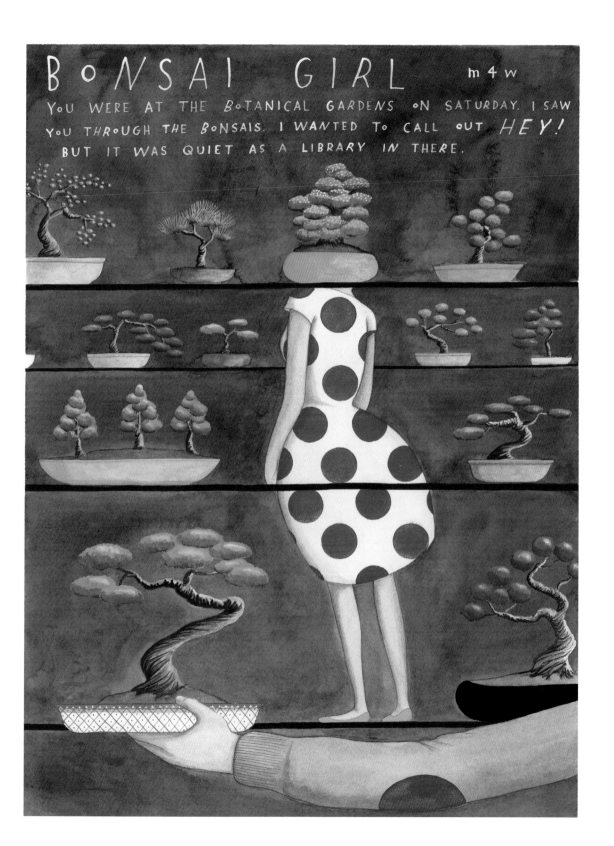

Black Dress, D Train

– M4W – 25

i kicked myself all the way home
for not saying hello
maybe you'll see this
and let me take you out
i was reading d h lawrence

BLACK DRESS, D TRAIN

-m4w 25

i kicked myself all the way home
for not saying hello
maybe you'll see this
and let me take you out
i was reading d h lawrence

Furry Arms in Morning Lecture

- M4M - 27

Noticed you the minute you walked into the room. White striped shirt, tie, and furry arms. We sat through the lecture and spoke briefly afterward.

FURRY ARMS IN MORNING LECTURE

-m4m 27

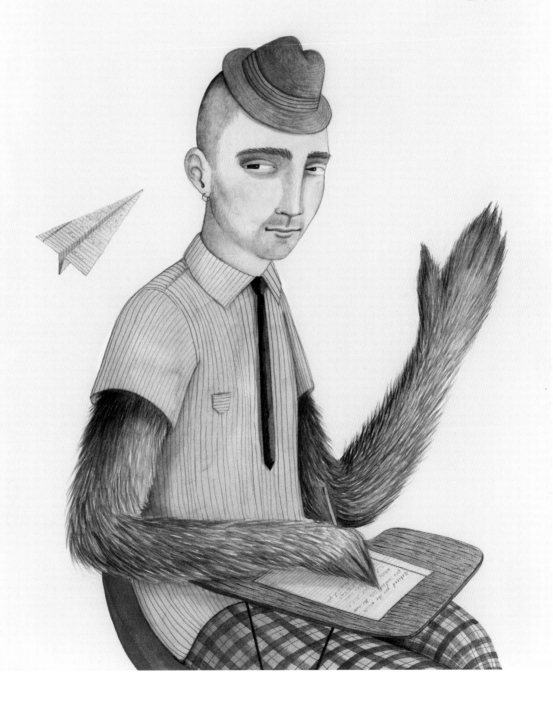

Green Hula Hoop in Tompkins Square Park

- W4M - 27
(EAST VILLAGE)

Yesterday you had a bright green hula hoop around your waist and you were VERY cute. Hope you reply.

Sunday, March 15
— w4m 27 (East Village)

GREEN HULA HOOP in TOMPKINS SQUARE PARK

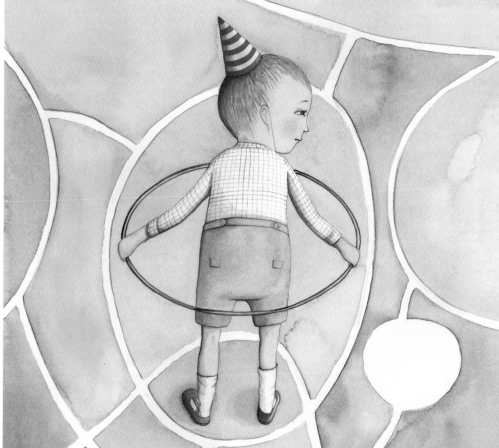

YESTERDAY YOU HAD A BRIGHT GREEN HULA
HOOP AROUND YOUR WAIST AND YOU WERE
VERY CUTE. HOPE YOU REPLY.

Tattooed Girl

- M4W
(DANBURY GAS STATION)

So you came in out of the rain to do your paperwork and
could only show me a few tats . . . I saw the scissors and
would love to see the rest. Wednesday came and went.
I am still waiting.

TATTOOED GIRL

-m4w

DANBURY
GAS STATION

SO YOU CAME IN OUT OF THE RAIN TO DO YOUR PAPER-
WORK AND COULD ONLY SHOW ME A FEW TATS. I SAW
THE SCISSORS AND WOULD LOVE TO SEE THE REST.
WEDNESDAY CAME AND WENT. I AM STILL WAITING.

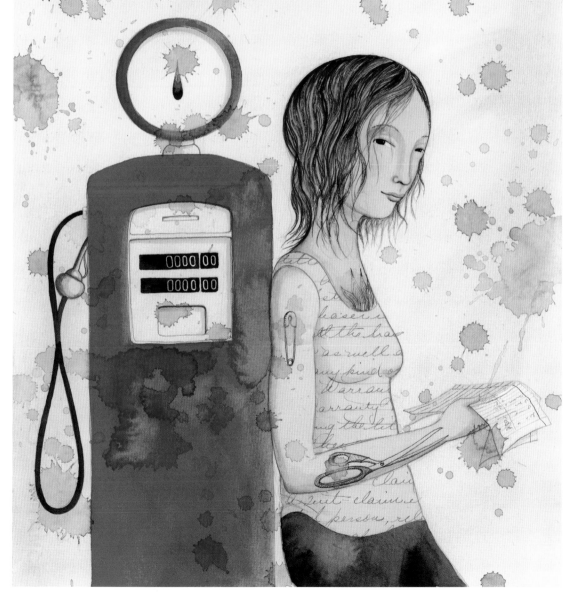

My Dreamy Neighbor Who Plays Obscenely Loud Music

– W4M

Sometimes when you have played music late into the night . . . or come home in the wee hours and turn it on, I knock on our shared wall or scold you the next day, but all along I am thinking how dreamy you are and how I just want to make love to you.

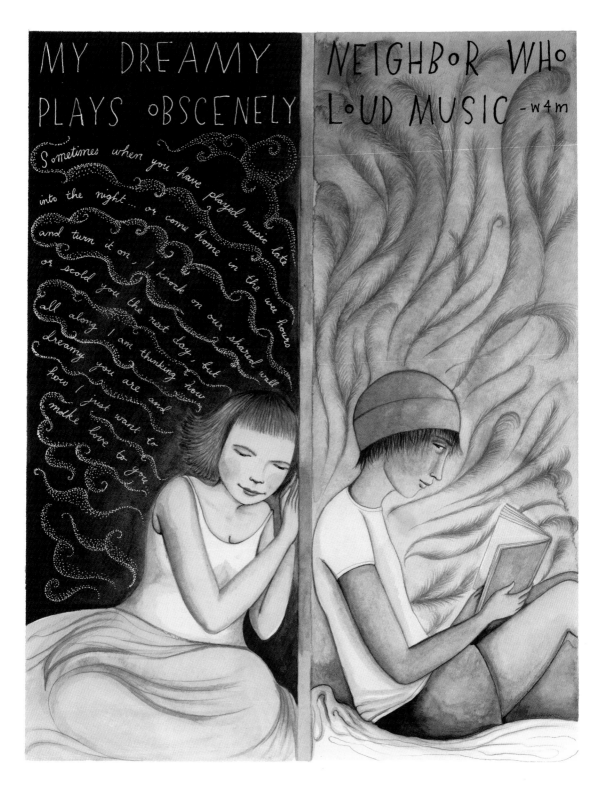

I Gave You My Umbrella but the Wrong Directions

– M4W

It was windy and pouring rain last night, and you were looking for directions in the East Village. You were wet and cold, so I gave you my umbrella. Unfortunately, I later discovered that I gave you the wrong directions and I feel just awful about it. I hope you and your friends got to your destination without too much trouble.

I GAVE YOU MY UMBRELLA
BUT THE WRONG DIRECTIONS
m4w

I Was the Face Painter @ Party Today

– W4M

i was the face painter at party today and you were there.

jake?
jason?
john?
something or another.

you had a nice face.

i would of liked to have stayed and chatted but me and my
coworker had other parties to attend to.

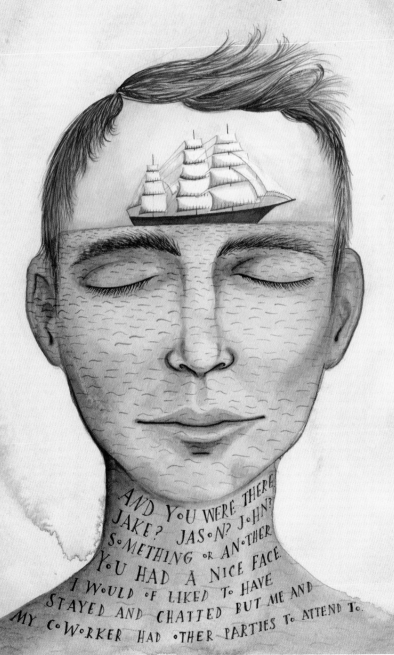

Girl with the Golden Swan Bike

- M4W - 28
(DUMBO)

Saw you sailing up Jay Street around 4pm on the most glorious golden bike. I think I'm in love.

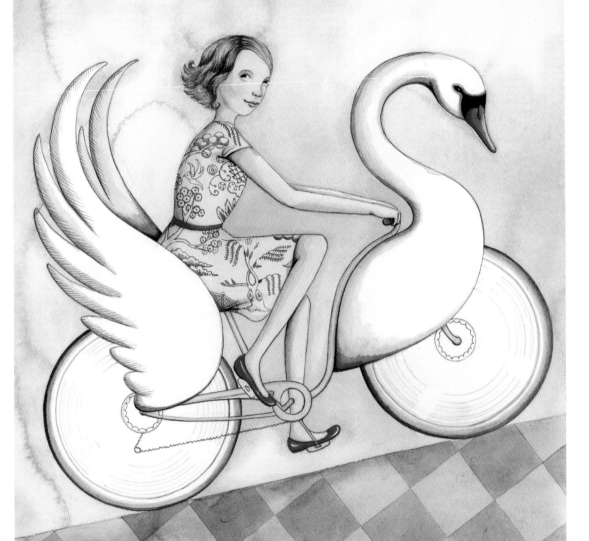

GIRL WITH THE GOLDEN SWAN BIKE
m4w 28 DUMBO

SAW·Y·U SAILING UP JAY STREET
AR•UND 4PM ON THE MOST GL•RI•US
G•LDEN BIKE. I THINK I'M IN L•VE.

You Came to My Tea Shop

- M4M - 20

You had the BEST eyelashes, and were a handsome devil.
Wish I would have asked you out. Ha!

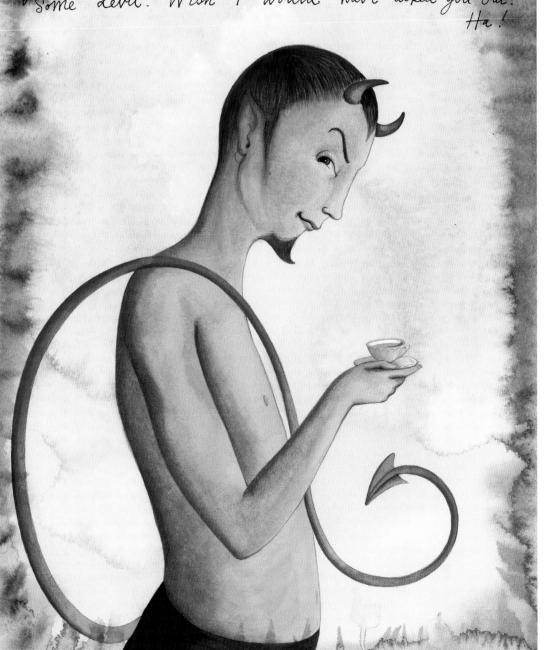

YOU CAME TO MY TEA SHOP
-m4m 20

You had the BEST eyelashes, and were a hand-some devil. Wish I would have asked you out. Ha!

The Whale at Coney Island

- M4M - 69
(BROOKLYN/FLORIDA)

A young friend of mine recently acquainted me with the intricacies of
Missed Connections, and I have decided to try to find you one final time.

Many years ago, we were friends and teachers together in New York City.
Perhaps we could have been lovers too, but we were not. We used to take trips to
Coney Island, especially during the spring, when we would stroll hand in hand,
until our palms got too sweaty, along the boardwalk, and take refuge in the cool
darkness of the aquarium. We liked to visit the whale best. One spring, it arrived
from its winter home (in Florida? I can't remember) pregnant. Everyone at the
aquarium was very excited — a baby beluga whale was going to be born in New
York City! You insisted that we not miss the birth, so every day after class, and on
both Saturday and Sunday, we would take the D train all the way from Harlem to
Coney Island.

We got there one Saturday as the aquarium opened and there was a sign
posted to the glass tank. The baby beluga had been born dead. The mother,

the sign read, was recovering but would be fine. We read the sign in shock and watched the single beluga whale in her tank. She was circling slowly. Neither of us could speak. Suddenly, without warning, the beluga started to throw herself against the wall of the tank. Trainers came and ushered us out. We sat on a bench outside, and suddenly I felt tears running down my face. You saw, turned my face towards yours, and kissed me. We had never kissed before, and I let my lips linger on yours for a second before I stood up and walked towards the ocean.

It was too much — the whale, the death, the kiss — and I wasn't ready.

Forgive me — I don't think I ever understood what an emptiness you would create when you left and I realized that that kiss on Coney Island was the first and the last.

Are you out there, dear friend?

If so, please respond. I think of you, and have thought of you often, all of these years.

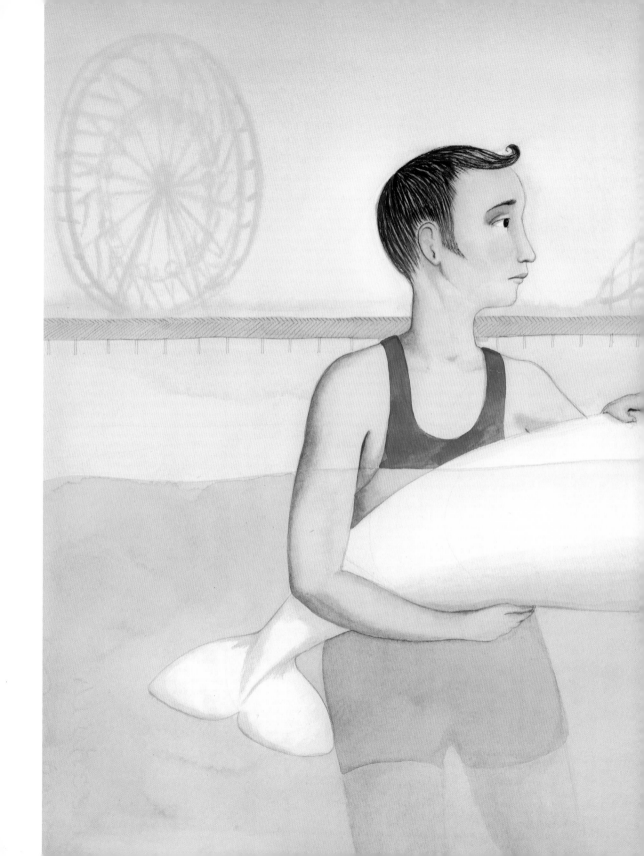

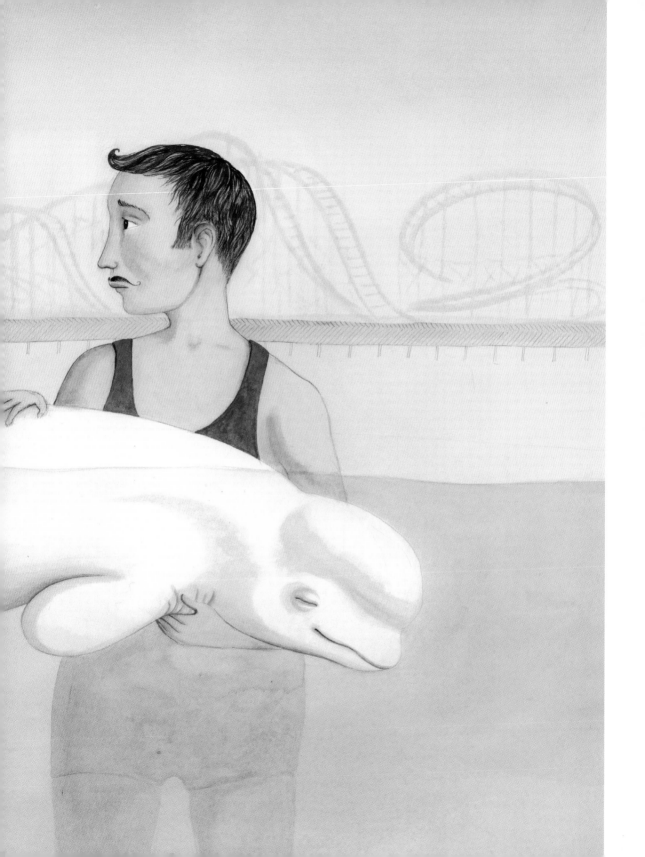

Dark Skinned Well Spoken Lady

– M4W

I help you almost once a week at the grocery store with your seafood purchases. I doubt you'll see this, but if you do, please respond back. I'll know it's you when you tell me the specific seafood you ask for each week.

DARK SKINNED WELL SPOKEN LADY m4w

I HELP YOU ALMOST ONCE A WEEK AT THE GROCERY STORE WITH YOUR SEAFOOD PURCHASES. I DOUBT YOU'LL SEE THIS, BUT IF YOU DO, PLEASE RESPOND BACK. I'LL KNOW IT'S YOU WHEN YOU TELL ME THE SPECIFIC SEAFOOD YOU ASK FOR EACH WEEK.

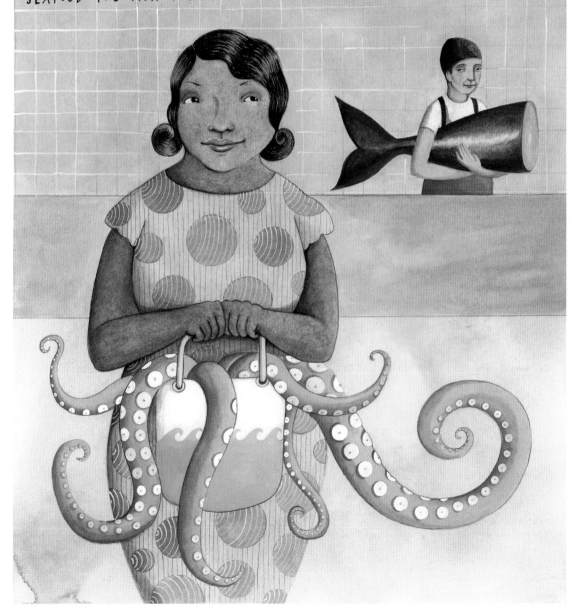

Scrabble Tattoo on Roof

– M4W
(GREENPOINT)

asked myself why the letter 'n' all night long then you were gone before i got the chance to ask. also, i saved you a piece of cake. do you always sit in a circle of asian girls? and sit at the top of the stairs so everyone gets a crush on you when they get to the roof?

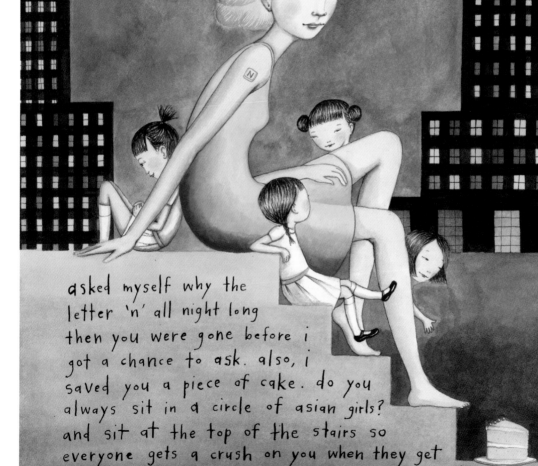

Monday, August 17 — m4w
(greenpoint)

SCRABBLE TATTOO on ROOF

asked myself why the
letter 'n' all night long
then you were gone before i
got a chance to ask. also, i
saved you a piece of cake. do you
always sit in a circle of asian girls?
and sit at the top of the stairs so
everyone gets a crush on you when they get
to the roof?

Unbelievable Moustache on the C

- W4M - 28
(CHELSEA)

You: tall, brown hair, incredibly voluminous moustache,
blue/green checkered shirt
Me: tall, blonde, wearing all black and Burberry rain boots
I boarded the uptown C train at 14th Street at around 10:50
on Tuesday morning. You got off at 23rd. You were staring
at me. Hard. You're really really really ridiculously
good looking.

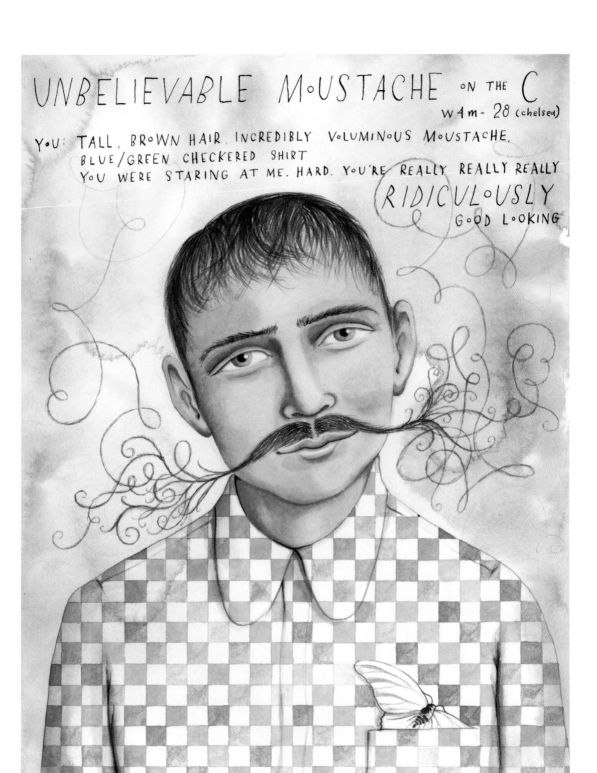

Anyone Know That White Girl with Black Hair & Old Fashioned Clothes?

– M4W
(THROGS NECK, EDGEWATER)

I've seen her around Throgs Neck & Edgewater, she's gotta be in her 30s and wears older clothes. What's the deal with her? She single or what?

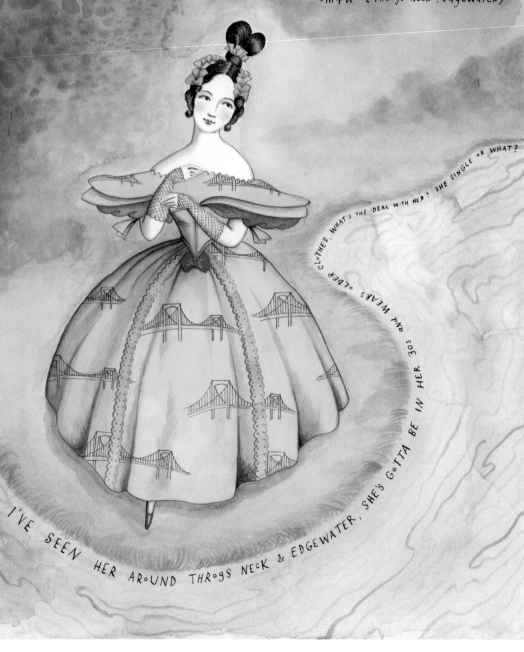

Hairy Bearded Swimmer

\- M4M \- 29
(ASTORIA)

we were both swimming around 5-6 in astoria pool.
we ended up walking the same direction in the park for
a while but didn't talk. i wish i had said hi . . . so i figured
i would on here. worth a shot.

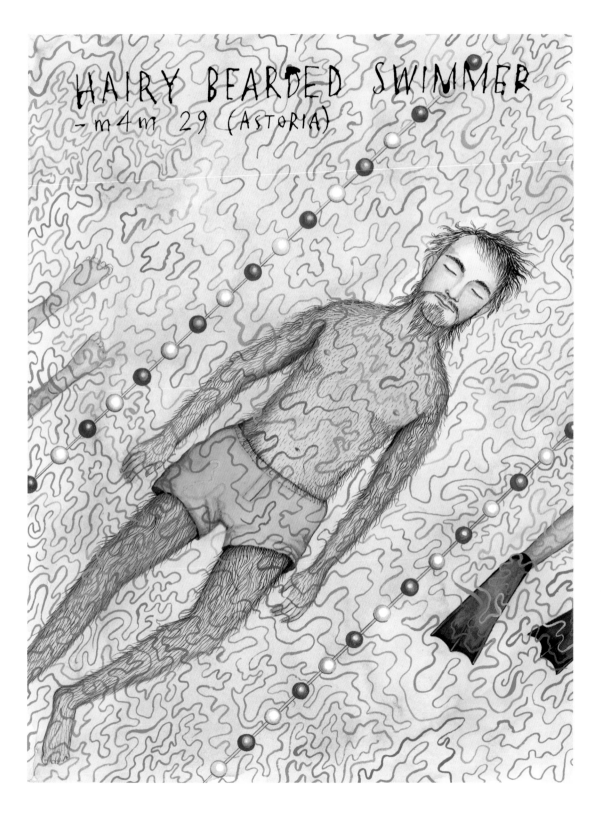

Dear Girl with Silk Screen on the M

- M4W
(RIDGEWOOD)

I wasn't following you; I live down that block.

Owl Lady in the Red Dress

– M4W – 25

We both purchased owl statues today. You are the classy looking dame in a red dress. I am the mustachioed gentleman. I think we should meet up and discuss further wildlife decor.

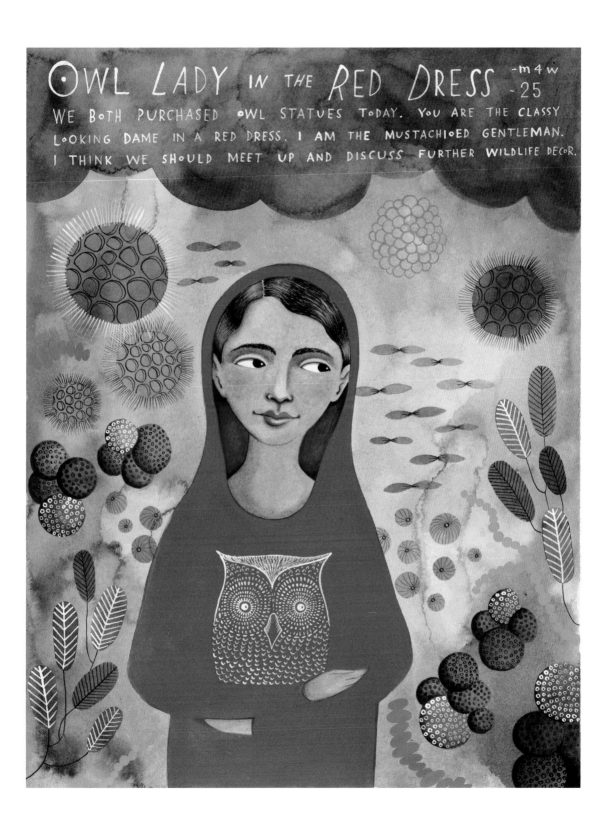

Knitting Girl on 7 Train to Sunnyside

– M4W – 28

Not only did you introduce me to the wonderful world of knitting, I quickly found myself smitten with you after chatting for a few minutes. Despite you mentioning you had a boyfriend, I can only hope he is terminally ill so that I'll get a shot at knitting something for you one day. You were one of the warmest people I've met on a subway at 2am, and a reminder why I love this city.

KNITTING GIRL ON 7 TRAIN TO
Sunnyside — m4w 28

NOT ONLY DID YOU INTRODUCE ME TO THE WONDERFUL WORLD OF KNITTING, I QUICKLY FOUND MYSELF SMITTEN WITH YOU AFTER CHATTING FOR A FEW MINUTES. DESPITE YOU MENTIONING YOU HAD A BOYFRIEND, I CAN ONLY HOPE HE IS TERMINALLY ILL SO THAT I'LL GET A SHOT AT KNITTING SOMETHING FOR YOU ONE DAY.

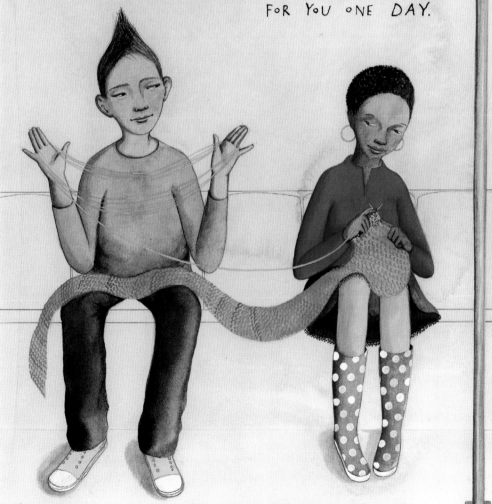

YOU WERE ONE OF THE WARMEST PEOPLE I'VE MET ON THE SUBWAY AT 2AM, AND A REMINDER WHY I LOVE THIS CITY.

Appliance Shopping

– M4M – 40

You were appliance shopping on Saturday. We kept running into each other in the store. I couldn't take my eyes off you. If this is you, tell me what I was carrying.

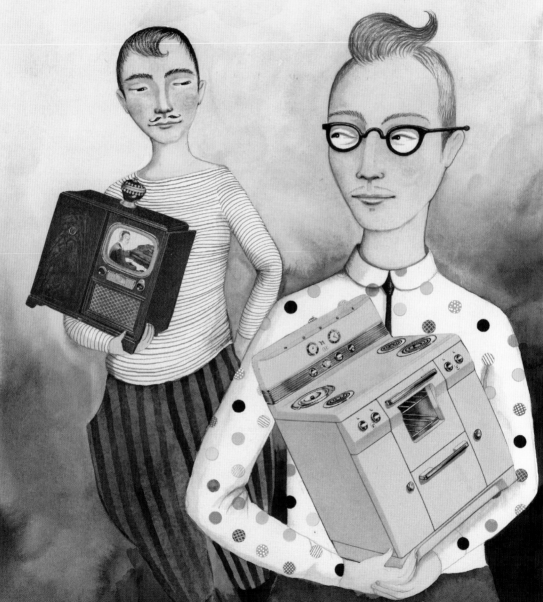

Seeking Girl Who Bit Me TWICE Last Night While We Were Dancing

- M4W - 27

So yea . . . um, looking for the girl who I was dancing with last night, she bit me twice. I forget her name.

Saturday, 6th June — m4w- 27
SEEKING GIRL WHO BIT ME TWICE LAST NIGHT
WHILE WE WERE DANCING

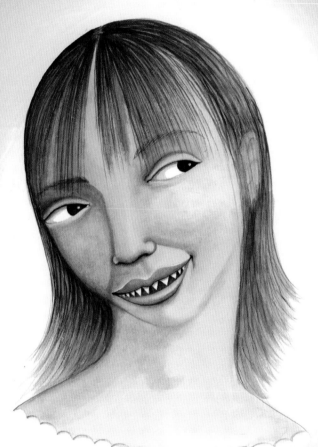

So yea... um, looking for the girl
who I was dancing with last night,
she bit me twice. I forget her name.

When I Put Your Coat Collar Up

– M4W

When I put your coat collar up to protect you from the cold . . .
on the corner of E. Houston & Bowery . . .
and I looked in your eyes . . .
I was very tempted to kiss you . . .
but I don't steal women from other men . . .

still . . .
I was tempted . . .

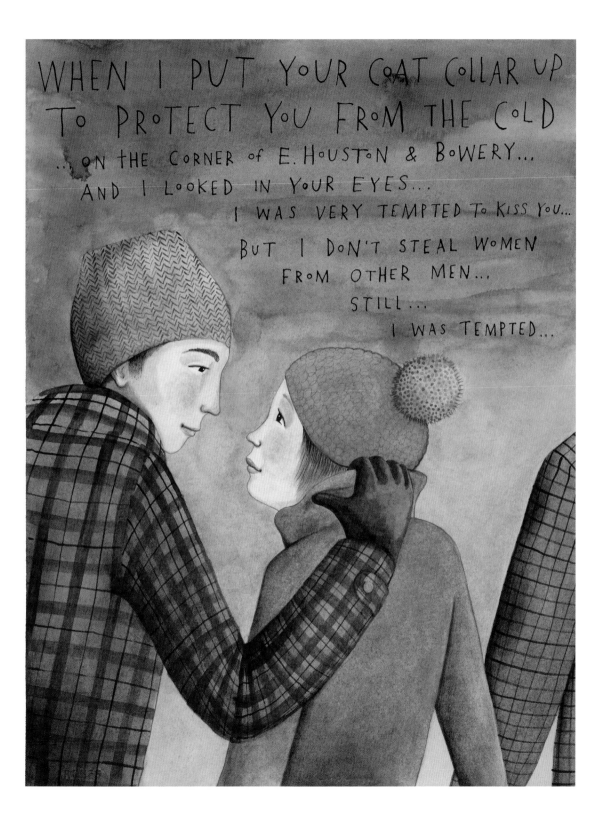

Cursive, on Leaving

– M4W
(EXITING TO THE STREET)

Cursive, on leaving, stepped on my foot
wish i could have stricken up a conversation

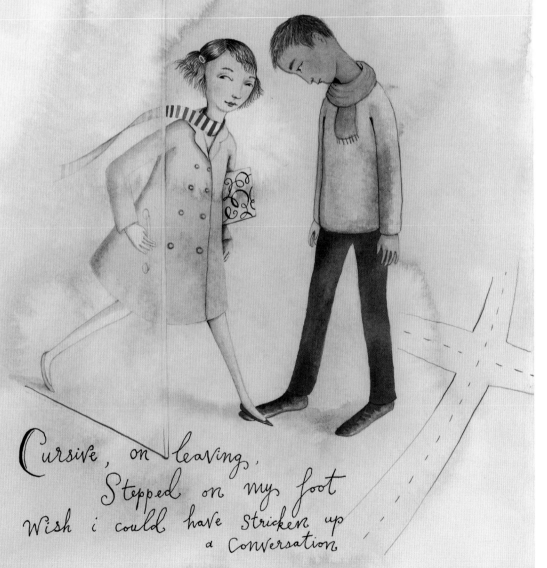

Tuesday, March 10
— m4w (exiting to the street)

Cursive, on leaving,
Stepped on my foot
Wish i could have stricken up
a conversation

Girl Sleeping on Train

\- M4W - 19

You were the gorgeous brunette sleeping on the train. I was the guy sitting next to you. I just wanted to apologize for my repeated lack of consciousness onto your shoulder, we both got off at flatbush. Hit me back up if you think this is you.

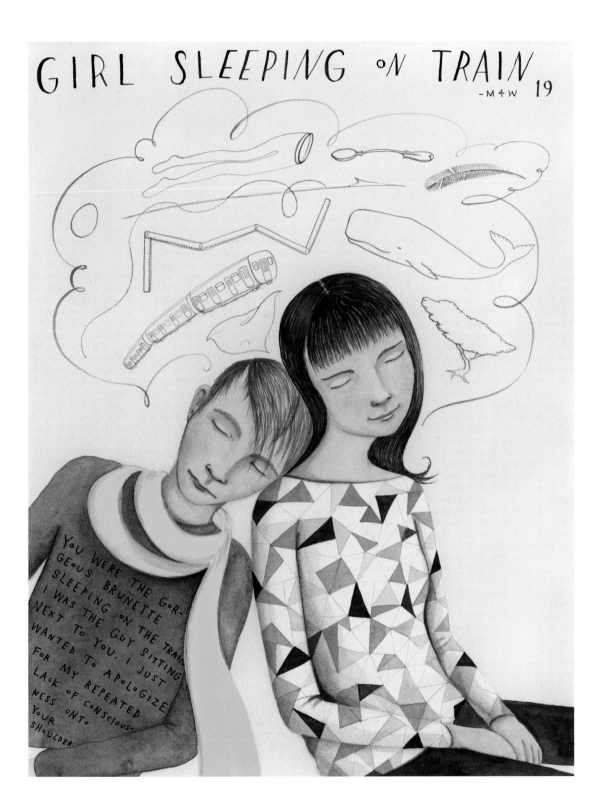

Ice Skating in Central Park
We Collided

- M4W - 32

You had on a furry hat with ear flaps and you crashed into me @ Wollman Rink today. You are a terrible but adorable skater.

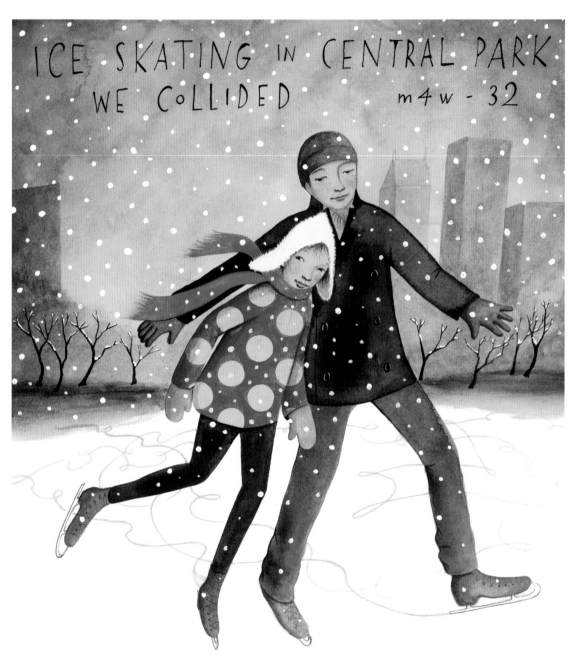

Tree with Legs

\- W4M
(PROSPECT PARK)

Nice pants. I'd like to see more of you . . .
BTW, your dog winked at me.

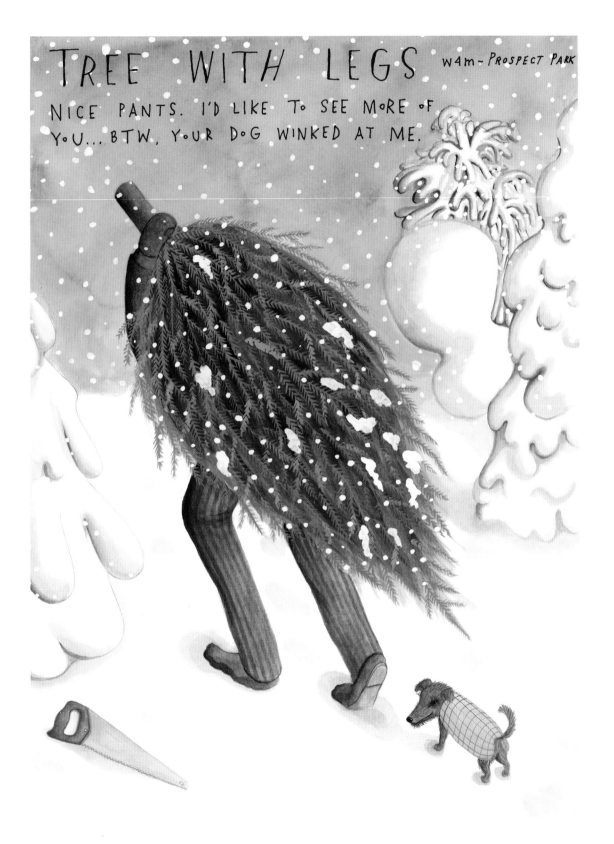

You Left Your Coat Here Last Winter

- W4W

. . . or rather, you let me wear it home.
I found fun dip in one pocket and your NYPL card in the other.
It's going to keep me deliciously warm this winter as I rack up
mountains of overdue fines.

YOU LEFT YOUR COAT HERE LAST WINTER —w4w

... or rather, you let me wear it home.
I found fun dip in one pocket and your
NYPL card in the other.
It's going to keep me deliciously warm
this winter as I rack up mountains
of overdue fines.

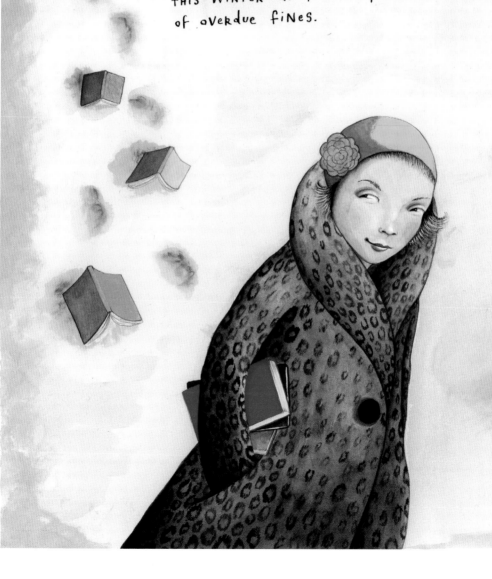

I Can't Believe I Found You

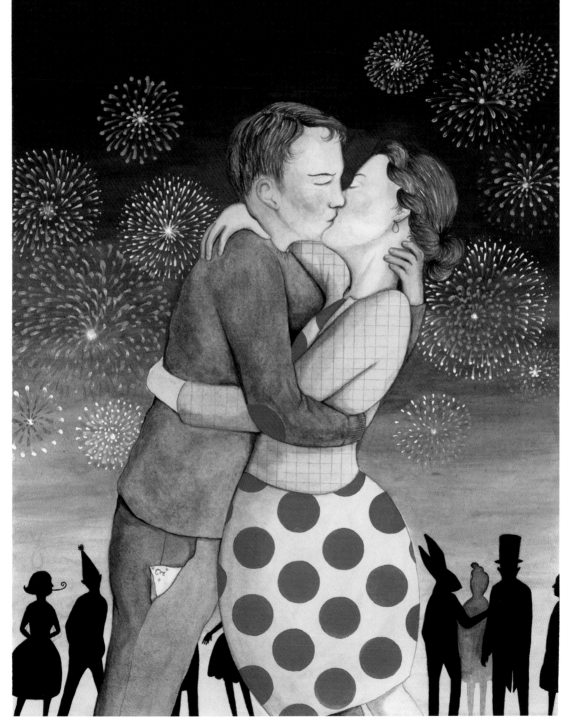

acknowledgments. First and foremost I would like to thank the thousands of people, whose names I will never know, who write Missed Connections and post them and allow me a glimpse into their lives. I thank them for being courageous enough to post those messages, but not quite so courageous as to have approached the other person in the first place.

I am enormously grateful to the hundreds of kind strangers who sent e-mails and left comments on my blog, and told me their stories and virtually breathed down my neck to keep me making pictures.

Many thanks go to the gracious group at Workman who have embraced this book, particularly Suzie Bolotin. And to Nancy Gallt, who has the best laugh and also my back.

Thank you to my family and friends, especially Olive, Eggy, and Nick Godlee, to whom I have often been less than attentive, and sometimes downright neglectful, but who always forgive me and bring me cups of tea.

Last of all I am deeply grateful to Ed Schmidt, for his serious and constant encouragement and support, and his delicate red pen.

about the artist. Sophie Blackall has illustrated over twenty books for children, including *Ruby's Wish*, *Meet Wild Boars*, *Big Red Lollipop*, and the *Ivy and Bean* series. Her editorial illustrations have appeared in *The New York Times*, *The Wall Street Journal*, *The Washington Post*, and many magazines. In 2000, she moved from Australia to Brooklyn, New York, where she lives with her family and a stuffed armadillo.

about the art. The illustrations in this book were painted with Chinese ink and watercolor on Arches hot press paper.